D0330513

Skira**M**ini**ART**books

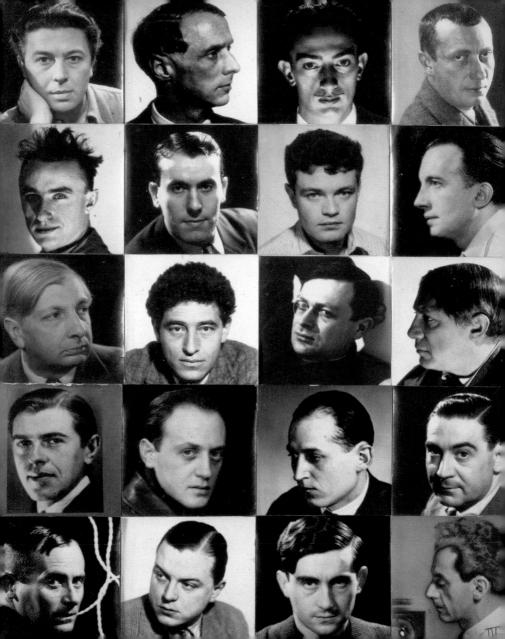

Flaminio Gualdoni

SURREALISM

front cover
Joan Miró
Carnival of Harlequin
(detail), 1924-25
Oil on canvas, 66 x 93 cm
Albright-Knox Art Gallery, Buffalo

Skira editore
SkiraMiniARTbooks

Editor
Eileen Romano

Design
Marcello Francone

Editorial Coordination
Giovanna Rocchi

Layout
Anna Cattaneo

Iconographical Research
Alice Spadacini

Editing
Maria Conconi

Translation
Christopher "Shanti" Evans
for Language Consulting
Congressi, Milan

First published in Italy in 2008
by Skira Editore S.p.A.
Palazzo Casati Stampa
via Torino 61
20123 Milano
Italy

www.skira.net

Printed and bound in Italy.
First edition

ISBN 978-88-6130-537-3

Distributed in North America by
Rizzoli International Publications,
Inc., 300 Park Avenue South,
New York, NY 10010.
Distributed elsewhere in the world
by Thames and Hudson Ltd.,
181a High Holborn, London
WC1V 7QX, United Kingdom.

facing title page
Man Ray
Surrealist Chessboard, 1934
(Breton, Ernst, Dalí, Arp, Tanguy,
Char, Crevel, Éluard, de Chirico,
Giacometti, Tzara, Picasso,
Magritte, Brauner, Péret, Rosey,
Miró, Mesens, Hugnet, Man Ray)
Original photomontage,
46 x 30.2 cm
Arturo Schwarz Collection, Milan
Courtesy Fondazione Mudima

Contents

Surrealism

At the end of the First World War many of the protagonists of the most recent developments in the avant-garde, and Dada in particular, gathered in Paris. Francis Picabia, Tristan Tzara, Man Ray, Marcel Duchamp and Max Ernst, the leading figures in the most radically revolutionary movement that art had ever produced, excited the admiration of a number of young and enterprising intellectuals. Outstanding among them were André Breton and Philippe Soupault.

The pair carried out experiments in automatic writing in the Dadaist manner and in 1920 published a book, *Les champs magnétiques* (*The Magnetic Fields*), that offered an ample demonstration of the technique. It was the foundation of a periodical that gave the new artistic climate a centre of gravity. *Littérature*, set up by Breton and Soupault in collaboration with Louis Aragon, was the laboratory in which they conducted the experiments out of which Surrealism would shortly be born.

The objective was still that of a total art, i.e. of a wide-ranging artistic attitude that cultivated all means of expression, from poetry to music, from drama to painting, playing down specific techniques and languages in favour of a creativity that was linked entirely to the moods of the individual and that chose, on each occasion, the most suitable medium with which to work.

It is no coincidence that the term originated in connection with a "total" work *par excellence*: Guillaume Apollinaire used the expression *sur-réalisme* in the programme of *Parade*, a complex performance staged on 17 May 1917 at the Théâtre du Châtelet with a scenario by Jean Cocteau, music by Erik Satie, scenes and costumes by Pablo Picasso and choreography by Léonide Massine.

Littérature promoted and organized soirées that, following the example of the Futurist evenings and the ones staged by the Cabaret

Voltaire in Zurich in 1916 from which the Dada movement had sprung, alternated readings and performances by authors with a literary background like Breton, Soupault, Aragon, Ribemont-Dessaignes, Éluard, Dermée, Birot, Radiguet and Cocteau with recitals by musicians like Satie, Auric, Poulenc and Milhaud and the exhibition of works by Gris, de Chirico, Léger, Picabia and Lipchitz.

Salvador Dalí
Mae West's Face which May be Used as a Surrealist Apartment (detail), 1934-35
Tempera on newspaper,
31 × 17 cm
The Art Institute, Chicago

For Breton Dada was a "state of mind", a mode of being capable of generating creative processes. His young emulators in Paris looked not so much to art as to the happening, to poetry, to the many ways in which that iconoclastic and irreverent attitude could be turned into spectacle. In addition, in keeping with the new avant-garde tradition ushered in by the Fauves and Cubists, there was a very great temptation to turn everything into an organized movement, something Dada had always rejected.

The crucial moment in the birth of Surrealism was the meeting between Tzara and Breton, both of them many-sided personalities in the manner of Marinetti: writers, performers, cultural organizers and pamphleteers driven by aggressive predicatory and prophetic instincts, they were incarnations of the figure of the tumbler, the mask, which was not just a favourite subject of 20th-century art but the very emblem of the avant-garde man, rootless, deviant and playfully critical of society's system of values.

Between 1920 and 1925 a series of Dada-style soirées were staged, along with lectures, acts of disturbance at official occasions (making news, grabbing the headlines, was a strategy inspired by Futurism), programmatic conferences, the distribution of leaflets, provoca-

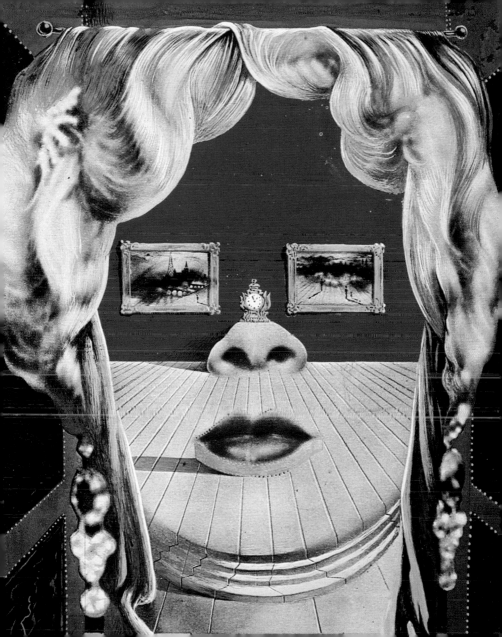

"Psychic automatism in its pure state, by which one proposes to express—verbally, by means of the written word, or in any other manner—the actual functioning of thought. Dictated by the thought, in the absence of any control exercised by reason, exempt from any aesthetic or moral concern."

André Breton

tive articles in periodicals and attacks on official culture as well as the snobbery of the new progressive culture, carried out with paradoxical arrogance.

From Dada the emerging movement of Surrealism inherited the idea of wanting to be a radical way of living and acting rather than a creative tendency in the strict sense. But it rejected, as is apparent from the rupture between Tzara and Breton that took place in 1922 amidst fierce controversy, Dada's opposition to modernity and art, whose vaguely apocalyptic and nihilistic undercurrent it did not share. On the contrary Breton and his friends, fascinated by the Soviet revolution, stressed the risk entailed in Dada's lack of social and cultural commitment.

Until 1925 at least, Breton, who assumed the role of preacher and custodian of a revolutionary rigour and a professed Surrealist orthodoxy (numerous people were to be "excommunicated" over the years, including Soupault, Vitrac, Artaud, de Chirico and Aragon), paid only marginal attention to visual research, which had played a central role in Dada.

The prime interest of the collective research carried out by the early exponents of Surrealism was focused on languages in general, as codified systems of communication, regarded as mechanisms in which meaning was not so much revealed as distorted. In this sphere they rediscovered such examples as the poetry of Arthur Rimbaud, *Les Chants de Maldoror* by Isidore Ducasse, comte de Lautréamont and Raymond Roussel's *Locus Solus*, literary experiments in which clarity of form gave way to the obscure and ambiguous sound of the word, to the breakdown of the structure of discourse. They ventured into areas like esotericism, psychoanalysis, hypnosis, telepathy and sleep, in

11

other words states of altered consciousness and suspension of rationality in which, it was believed, people expressed their individuality in a way that was not filtered by habits: some, like Artaud and Michaux, took this to the extreme of experimenting with hallucinogens, although this had been a widespread practice among writers and artists since the 19th century. For the same reason they sought stimulation in the mystery of sexuality and the moment, irrational by definition, of erotic desire. Again, on a plane more closely linked to the modalities and techniques of language, great importance was assigned to the pun, the slip of the tongue, the verbal paradox and the joke: indeed Breton provocatively held up as a model to be followed a music hall performer called Dranem, famous for his songs based on risqué double meanings and verbal nonsense.

In the "Manifesto of Surrealism" written by Breton in 1924, he declared: "Psychic automatism in its pure state, by which one proposes to express—verbally, by means of the written word, or in any other manner—the actual functioning of thought. Dictated by the thought, in the absence of any control exercised by reason, exempt from any aesthetic or moral concern."

Typical, in this sphere, was a direct consequence of automatic writing, the *cadavre exquis* ("exquisite corpse"), practiced from 1925 on, which Breton and Éluard would describe as follows in the *Dictionnaire abrégé du surréalisme*: "A folded-paper game in which sentences or pictures are created by several people, none of whom can tell what the contribution of any preceding player may have been. The classic example, which supplied the name of the game, is the first sentence ever obtained in this way: 'The exquisite corpse shall drink the new wine'". Another product of these experiments was the se-

12

"It seemed and still seems to me
that the speed of thought
is no greater than that of words,
and hence does not exceed
the flow of either tongue or pen."

André Breton

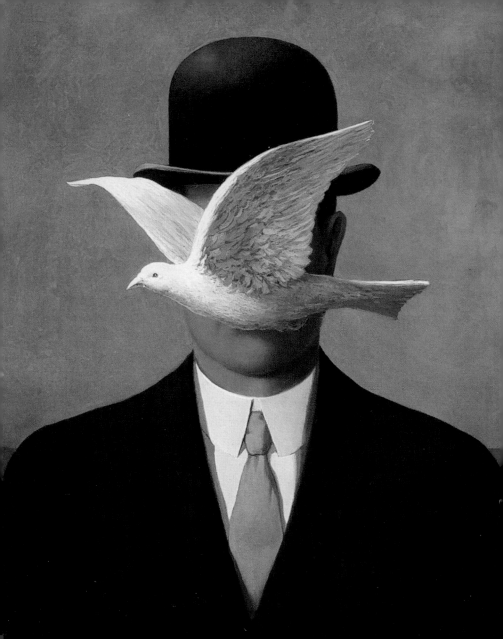

ries of aphorisms and plays on words created in a state of hypnotically induced sleep and transcribed by Robert Desnos, who published them from 1922 on under the name of Rrose Sélavy, the pseudonym previously used by Duchamp.

As far as more strictly artistic research was concerned, the question was less clearly specified and at the outset, it seems evident, considered secondary by Breton, who limited himself to indicating precedents of the Surrealist attitude in the dreamy atmospheres of "Le Douanier" Rousseau and the Metaphysical painting of de Chirico.

René Magritte
The Man with the Bowler Hat, 1964
Oil on canvas,
63.5 × 48 cm
A. Carter Pottash
Collection, New York

In any case, almost no encouragement to investigate a possible iconography of the Surreal came from the artists with a background in Dadaism. For a long time both Picabia, who held a solo exhibition at the Galerie Povolozky in 1920, and Duchamp avoided taking a stand in favour of the new movement. The exhibitions held by Ernst at the bookshop owned by Renée Hilsum and the young Joan Miró at the Galerie la Licorne in 1921 did not cause much comment, and neither did the Salon Dada in the same year, at which Arp and Ernst showed. Nor were de Chirico's small anthological exhibition at the Galerie Guillaume in 1922 and the first appearance of a still post-Cubist André Masson at Kahnweiler's the following year indications of a real tendency.

The turning-point came at the end of 1924, with the publication of the first issue of the review *La Révolution surréaliste* and the creation of the Bureau Central de Recherches Surréalistes, opened on 11 October 1924 at no. 15, Rue de Grenelle, as a sort of ideological

15

headquarters for the movement. Alongside writers like Éluard, Desnos, Crevel, Artaud, Péret, Vitrac, Baron, Soupault and Aragon, artists were among the outstanding contributors to the journal: Duchamp, Picabia, Ernst and Masson.

The following year Breton, sensing the changes that had taken place in artistic research, began to theorize about them in *Le Surréalisme et la Peinture*. This led to the staging of an exhibition at the Galerie Pierre with Arp, de Chirico, Ernst, Klee, Masson, Miró, Picasso, Man Ray and Pierre Roy.

Breton did nothing but present a picture of something that was emerging independently in the world of art. Even in the artistic field, nevertheless, he established and imposed an orthodoxy. In 1926, as guardian of this orthodoxy, he felt able to brand Ernst and Miró's set designs for the Ballets Russes as a sign of worldly compromise, on the grounds that it was impure work contaminated by its practical and mundane use. On the other hand, with the efforts he had made to proselytize such new names as E.L.T. Mesens, René Magritte, Yves Tanguy, Paul Delvaux, Salvador Dalí and Maurice Henry, he was expecting Surrealism to spread like wildfire, just as Futurism had done and as would in fact happen over the course of the thirties. With this prospect the Galerie Surréaliste, a venue for exhibitions and events, also opened its doors in 1926. From this moment on, Surrealism was a reality that the world of art recognized and respected.

Dream, dark areas of consciousness, psychic automatism, hallucination, and at the same time a continual encounter and clash of sign and word, of word and thing, of sign and thing. In the twenties Surrealism embarked, from the viewpoint of artistic manifestations, on a vast

16

"We do not want to reproduce, we want to produce, like a plant which produces a fruit, directly and not by intermediary. We want to produce directly, not indirectly."

Hans Arp

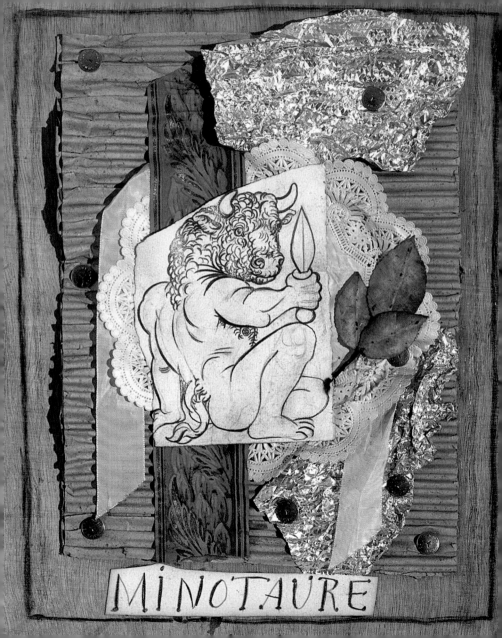

MINOTAURE

effort to expand the range of expressive possibilities, in a stylistic sense as well as in an anti-stylistic one, but above all on the plane of intellectual goals.

Duchamp and de Chirico were the poles chosen and indicated as extremes of these explorations: the former as implacable demolisher of conventions and formulas, capable of imparting new and different energy to every sign of the reality of existence; the latter, for his ability to distil a sense of visual and mental alienation through a masterly use of the most traditional codes of painting: the capacity of painting to represent what is seen analytically was turned by de Chirico into the unrepresentable, the ineffable.

Pablo Picasso
Cover of the Minotaure
Magazine, 1933
published by Albert Skira
Assemblage: cardboard,
metal, ribbons, printed
paper, artificial plant,
drawing pins and pen and
ink on paper mounted on
wood with charcoal,
48.5 × 41 cm
The Museum of Modern
Art, New York

Out of this came, at one and the same time, a mutable series of departures from the accepted rules of art and aesthetics and so slavish and intransigent an application of the same historical rules that it turned into a sort of paradoxical excess, which did not even stop at the borders of the kitsch. They were apparently contradictory approaches, but more than one artist explored the possibilities of both with extraordinary results.

This was the case with two of the early Surrealists, Ernst and Miró. In the early twenties the former, who while still part of German Dada circles had already created extraordinary collages with objects inserted in them, reflected a great deal on the estrangement of the image inaugurated by de Chirico, but applied it to further forms of object-collage, to experimental practices like frottage, which he began to promote in 1926, and, in his more mature years, to assemblage of objects of a sculptural type that would be crucial in the international research of the following decades. Within the group of Surrealists, Ernst's

19

imagery stood out for its Nordic visionary character, inclined to the monstrous, continually breathing an atmosphere of disquiet and anguish and filled with learned references, to everything from literature to Renaissance esotericism.

For his part Miró, while making incursions into the combination of objects and painting, remained for the most part within the limits of a technically orthodox painting that was homogeneous on the stylistic plane, relying instead on dense iconographic phantasmagoria. Taking signs from primitive cultures, from biology and from children's stories and fantasy, he assembled visions of potent perceptual richness and limpid wonder, backed up by a sumptuous use of chromatic relationships, a spatiality tending to the two-dimensional mosaic and a sophisticated virtuosity of execution. Miró was always careful to maintain a balance between the autonomous expressive capacity of the elements of the painting and the fascination of the images. As a result he was taken as a model by American Abstract-Surrealist research, and Roberto Matta and Arshile Gorky in particular, a current whose beginnings can be traced to the exhibition *Fantastic Art, Dada, Surrealism* at the MoMA in New York, which opened in December 1936. Another figure with a background in Dada like Ernst was Man Ray, who in these years, in addition to continuing with the practices of painting and the *ready-made*, introduced his "rayographs" in 1922. Based on the technique of contact printing, and used in parallel with photomontage and solarization, these showed that photography could be turned into an independent medium of expression, easier to assimilate to other practices of art. However, Ray's aim was not to win photography the status of an art form in its own right, a question that periodically reared its head in the avant-garde debate, but to demon-

strate that the unbounded universe of the surreal image could find expression in technically and stylistically different works, in a world at last liberated from the hierarchy between the arts and the imperative of manual dexterity. In these same years Man Ray was also engaged in a series of cinematographic experiments. After the precedents of Léger's *Ballet mécanique* in 1921 and Hans Richter's first films, he made *Le Retour à la raison* in 1923, took part with Duchamp, Picabia and Satie in René Clair's *Entr'acte* in 1924, and in 1926 made *Anémic cinema*, with Duchamp again and with Marc Allégret, and *Emak Bakia* by himself. In 1929, the same year as Luis Buñuel and Dalí made *Un Chien Andalou*, whose screenplay was published in issue no. 12 of *La Révolution Surréaliste*, he shot *Les Mystères du château de Dé*.

Experiments of this kind had an "anartistic" value in the Duchampian sense, in other words they were not intended to mean or express anything, but simply to pay tribute to chance, to the absurd, to the multiple stumbling blocks of reason and language. The cinema, now the object of mass cultural consumption as a form of narration by images, was subjected to the same procedures of destructuring of form and meaning that had been applied to the other arts. Joseph Cornell, an American who specialized in the assemblage of highly poetic box/theatres containing found objects arranged to create alienating visions, also devoted himself to the montage of clips from miscellaneous films, obliging viewers to forgo the story and give themselves up to the pure fascination of the flow of images.

The exponents of the current that adopted the more classical and recognized forms of painting, starting with the presumption that a figuration of a realistic type completely represented the visible, only to

21

force them to produce paradoxical results, were Masson, Tanguy, Magritte and Delvaux.

Masson, whose name is linked to the mixture of sand with paint to obtain effects of irritation and surface texture, and in the following decade to an intense use of automatic drawing, moved on around the middle of the twenties to a sort of evocation of Cubist chromatic and iconographic rigour in which he brought together recognizable forms in a way that created absurd effects.

More complex is the case of Tanguy who, harking back to the old tradition of "monstrous" painting, organized scenarios of a natural, representative kind in which he introduced apparitions somewhere between the oneiric and the ambiguously biological. The aim, achieved in part through a style that evoked illustration, was to create an effect of wonder induced by the elimination and deviation of what the observer expected to see.

Erwin Blumenfeld
Euch Bürgern, 1924
Collage and Indian ink
on paper, 26 × 21.5 cm
Paolo Della Grazia
Collection, Archivio
di Nuova Scrittura,
Museion, Bolzano

The work of Magritte was at a much higher qualitative and conceptual level. Adopting a polished style very close to—when not actually overlapping with—*trompe l'oeil*, he created images in which the impression of space was always highly arbitrary and misleading: not scenes and situations, but a sort of crystalline hallucination representing the short-circuit between things and the words, or conventions, that designate them, or a metaphysical apparition of elusive and abstruse games of mirrors between what is seen and what it usually signified and came to signify differently in this cryptic and paradoxical figuration. He wrote: "My manner of painting is absolutely banal and academic. What matters in my painting is what it shows". Unlike in the Nordic, cruel and disturbing

EUCH BÜRGERN!,

ICH GÖNNE EUCH EURE ETHIK
GOETHEN BIER KAFFE'ÄSTHETIK
KANTEN UN ETHOSPOTETIK
UN EURE BOHEM VON
MÜRGERN.

übrigens, der Höhepunkt der
Bürgerei sind die Konum-
nistischen Flausen.

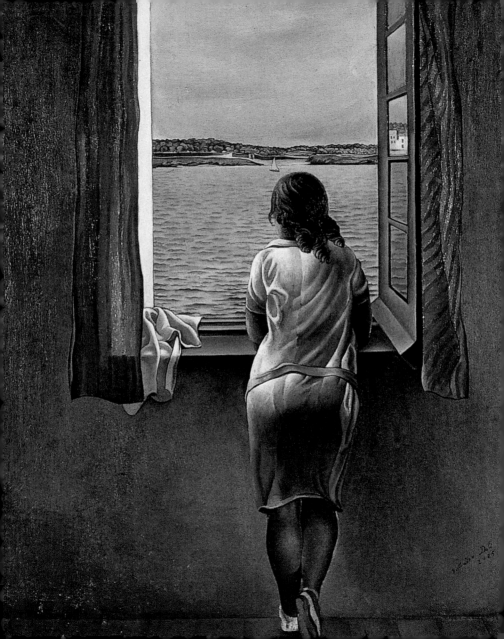

visions of Ernst, or the fabulous and ironic marvels of Miró, in Magritte's paintings the problem is one of truth, of representation, of meaning. In a similar way, Delvaux used a backdrop of apparently clear and illustrative images to introduce subtle and ambiguous atmospheres somewhere between the oneiric and the erotic.

Dalí is a case apart. Disliked by the other exponents of the movement for his exhibitionistic egocentrism and for the way that he sought success by deliberately putting his personal fame before the work itself, he was the theorist of "critical paranoia", which he defined as a "spontaneous method of irrational knowledge based on the critical and systematic objectification of delirious associations and interpretations". The images were phantoms that stirred in the artist's unconscious: he sought to represent them on the canvas, using a procedure akin to that of automatic writing, critically elucidating in the process of painting that which the irrational—what Dalí called paranoia—had brought to the surface. Out of this came the nightmarish climate of his works, and an iconography in which symbolic and allusive figures were combined in a hallucinatory fashion.

Salvador Dalí
Figure at a Window (*Young Woman Standing at the Window*) (detail), 1925
Oil on canvas, 103 × 75 cm
Centro de Arte Reina Sofía,
Museo Nacional, Madrid

It was in the midst of this labyrinth of experiences that the reflection on a new possibility for sculpture, provocatively announced at the beginning of the century by Boccioni and Picasso and taken up in particular by Brancusi, reached a crossroads. From Duchamp's *ready-mades* and Man Ray's "Objects of My Affection", sculpture had derived the certainty that its difference from banal reality lay not in its technical and material constitution, but in the capacity to present it-

25

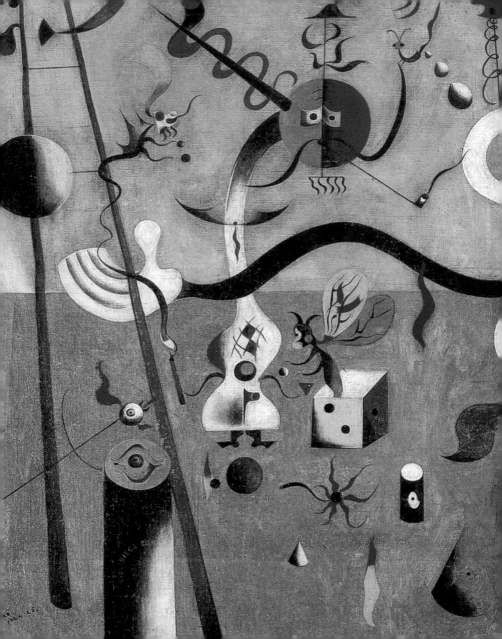

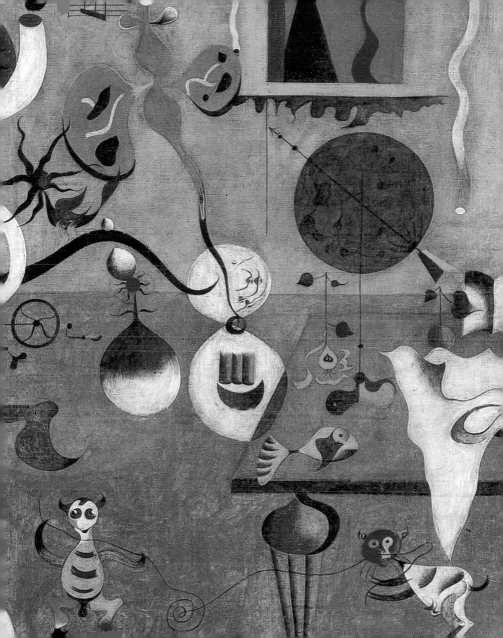

self as a distinct nucleus of meaning, as a concrete anomaly, endowed with a halo of magical or sacred diversity in the panorama of everyday experience.

Again it was Picasso, in the paintings and above all the sculptures of the late twenties that looked to Surrealism, who marked this turning-point. In parallel, the figures of Julio González and Alberto Giacometti attained their maturity. The former, very close to Picasso, worked on a series of masks and totems that oscillated between an anthropological recovery of the idea of face and body, and a process of formation in which the initial geometric elements appeared to obey almost organic rules of growth. His sculptural work, along with that of Picasso, was to serve as a model for the practice of assemblage following the Second World War.

Previous pages
Joan Miró
Carnival of *Harlequin*
(detail), 1924-25
Oil on canvas, 66 × 93 cm
Albright-Knox Art Gallery,
Buffalo

Giacometti, close in these years to the activities of the Surrealists, used sculpture to construct situations of a theatrical type, or forms of an organic kind in which he emphasized the parts in an anomalous way to produce results that looked like natural paradoxes.

In both artist's work the theme of a sculpture that in some ways emulated biological growth was clearly present, but it was in Arp's sculptures of this period that this was taken to an extreme. "We do not want to reproduce, we want to produce, like a plant which produces a fruit, directly and not by intermediary. We want to produce directly, not indirectly", wrote the artist, going on to say: "Often a detail of one of my sculptures, an outline, a contrast seduces me and becomes the seed of a new sculpture. I accentuate an outline, a con-

trast and that results in the birth of new forms. Among these, certain of them, two perhaps, grow more quickly and strongly than the others. I let them grow until the original forms become accessory and almost unimportant. Finally, I suppress one of these accessory and unimportant forms to set the others free".

Alongside these experiences there was a more direct revival of the *ready-made* in manipulations of objects, of which the most famous example is Meret Oppenheim's *Objet – Déjeuner en fourrure* (*Object – Lunch in Fur*), which blends evocations of the everyday with hints of subtle eroticism.

At the end of the decade the unruly group of Surrealists broke up definitively. Breton's decision to move on to a more explicit politicization of the movement, which would lead him to cease publication of *La Révolution Surréaliste* and bring out instead, between 1930 and 1933, *Le Surréalisme au service de la Révolution*, estranged authors like Bataille, Leiris, Limbour, Masson and Vitrac, more interested in the exploration of themes like anthropology and the sacred, which they tackled in the journal *Documents*, founded in 1929.

Then, in 1933, the review *Minotaure*, founded by Albert Skira, became a vehicle for the representatives of the more strictly artistic front: Arp, de Chirico, Miró, Duchamp, Man Ray, Masson, Magritte, Tanguy, Dalí and Bellmer.

In January 1938 the *Exposition Internationale du Surréalisme* was held at Georges Wildenstein's Galerie des Beaux-Arts in Paris, a celebration of the movement that took place at the very moment it reached its crisis point.

• Dream • Hallucination • Dar
Psychic automatism • At once
of sign and word • Of word a

areas of the consciousness •
ntinuous meeting and collision
thing • Of sign and thing •

Works

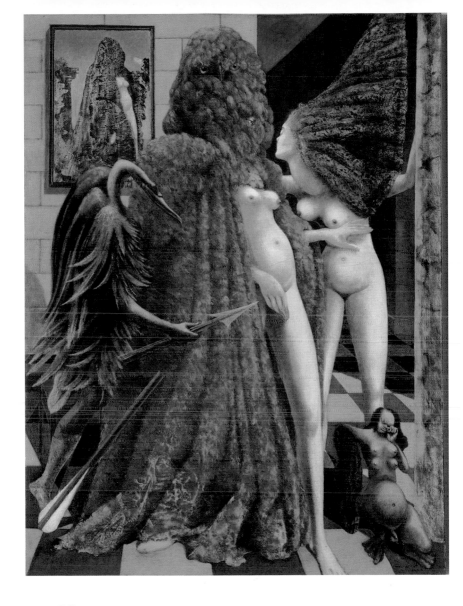

33

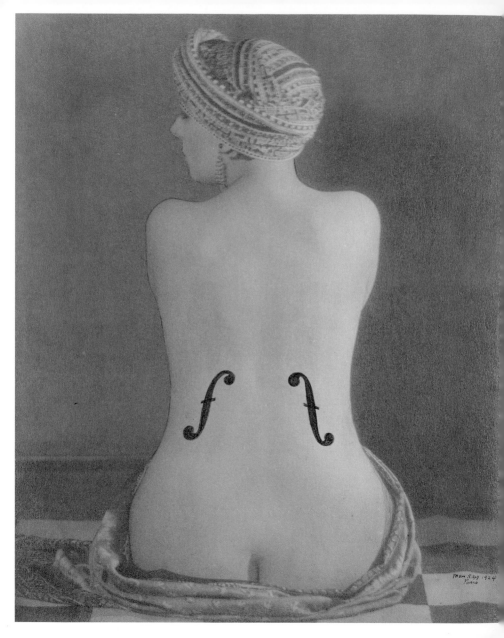

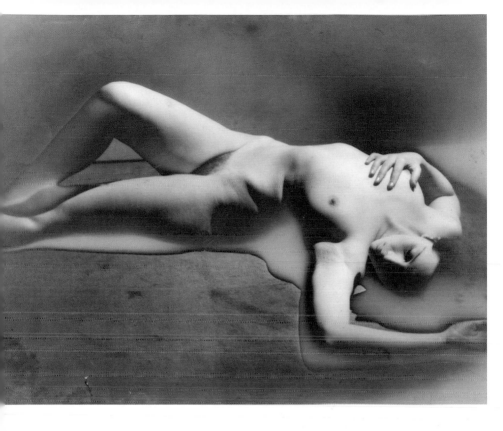

Previous page
1. Max Ernst
Attirement of the Bride,
1939-40

2. Man Ray
Le Violon d'Ingres, 1924

3. Man Ray
Primacy of Matter
over Thought, 1929

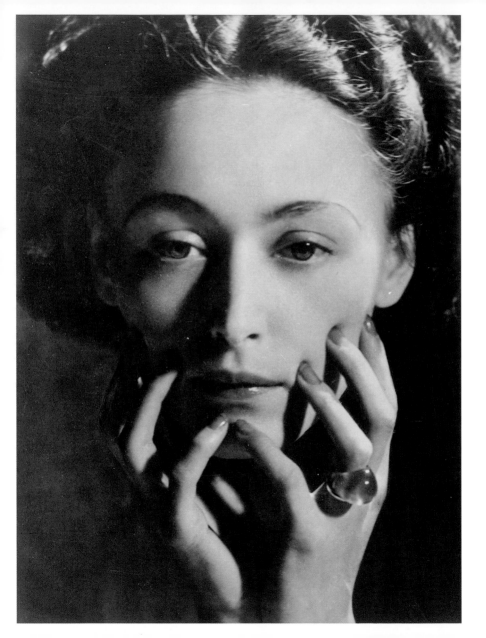

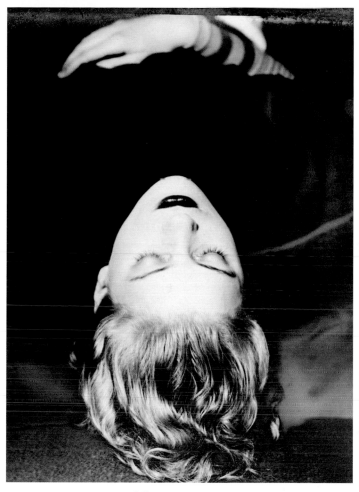

4. Dora Maar
Nusch Éluard, circa 1935

5. Man Ray
Lee Miller, circa 1930

Following pages
6. Man Ray
*Venus with Mirror
and Lamp,* 1931-59

7. Francis Picabia
*Transparencies – Head
and Horse,* 1930

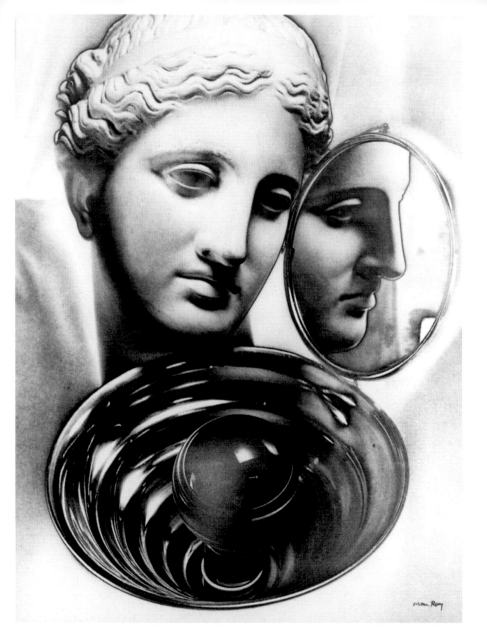

Man Ray

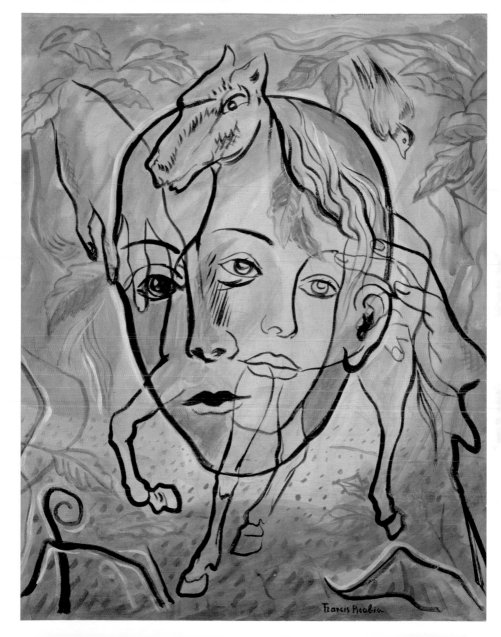

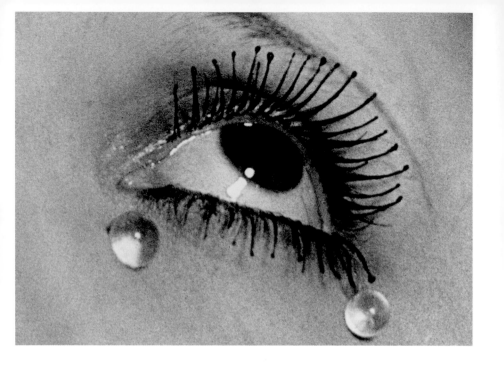

8. Man Ray
The Tear (Variant), 1932

9. Man Ray
Dora Maar, 1936

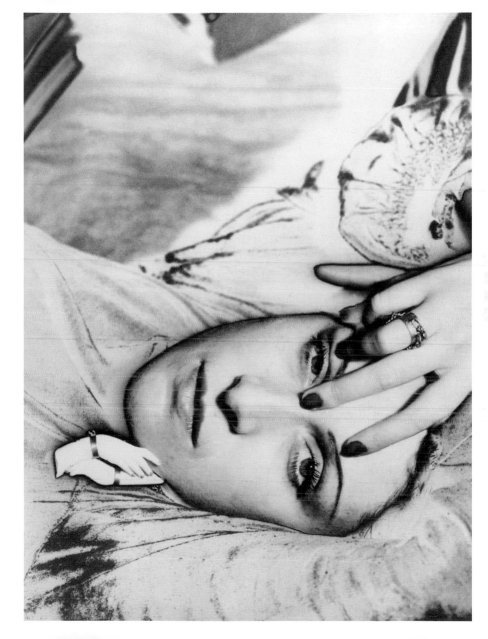

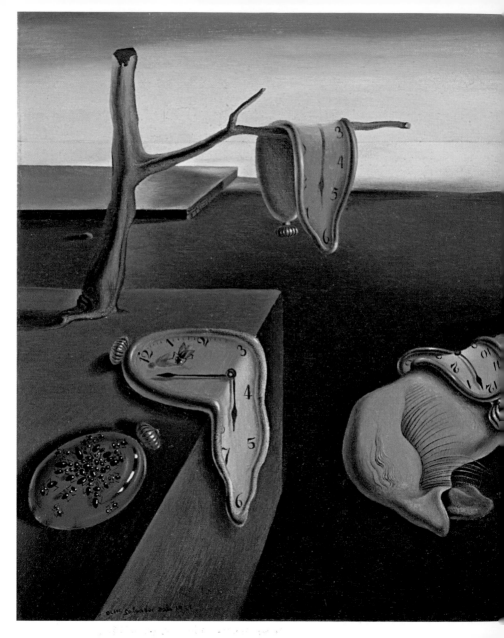

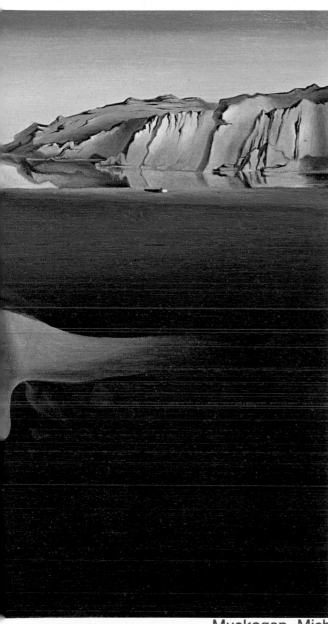

10. Salvador Dalí
*The Persistence
of Memory*, 1931

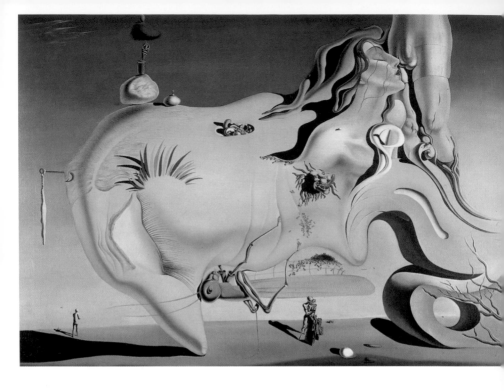

11. Salvador Dalí
The Great Masturbator,
1929

12. Salvador Dalí
The Lugubrious (or *Mournful*)
Game, 1929

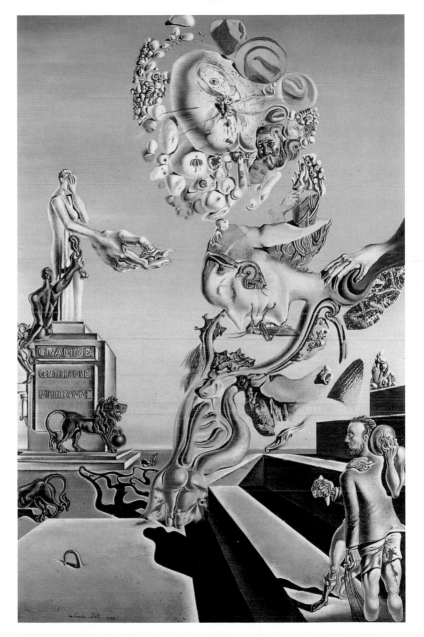

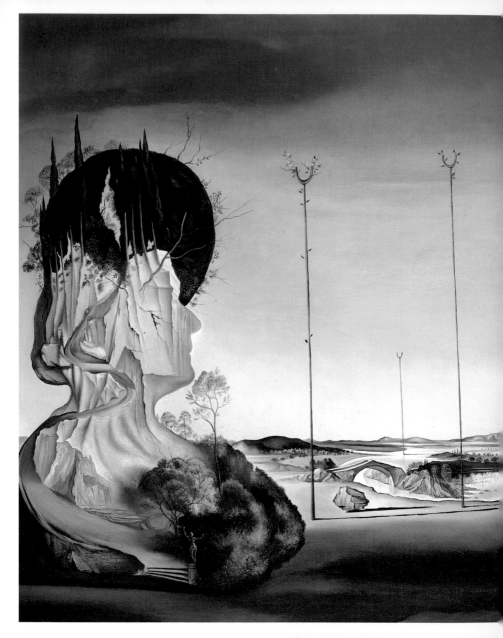

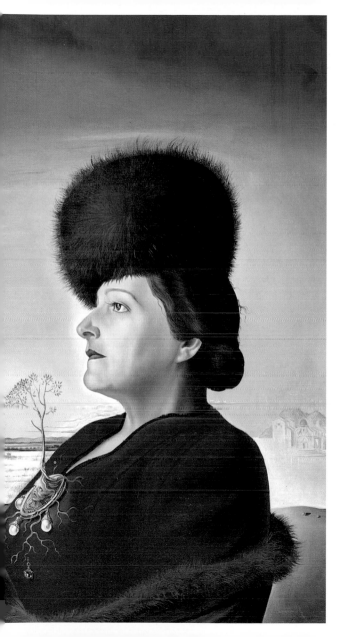

13. Salvador Dalí
Portrait of Mrs. Isabel Styler-Tas (Melancholia), 1945

Following pages
14. Yves Tanguy
Extinction of Useless Lights, 1927

15. Yves Tanguy
Dead Man Watching His Family, 1927

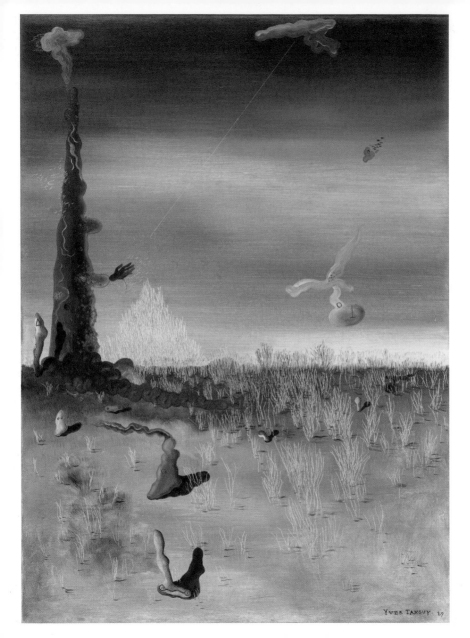

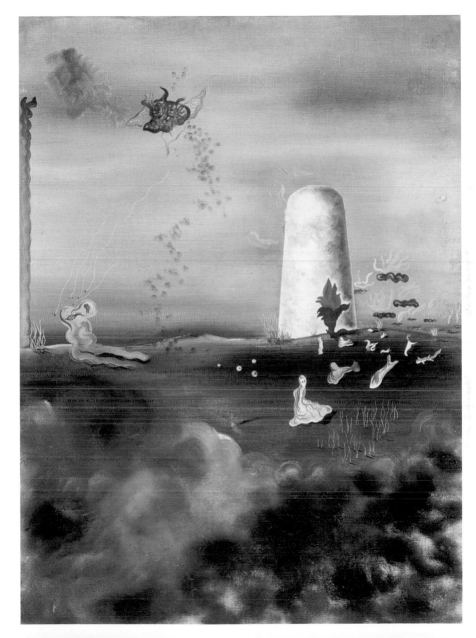

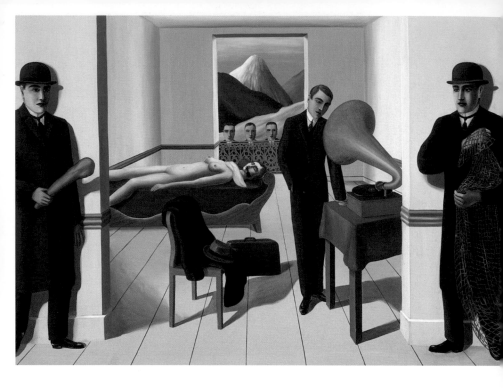

16. René Magritte
The Menaced Assassin, 1926

17. René Magritte
Man with a Newspaper, 1928

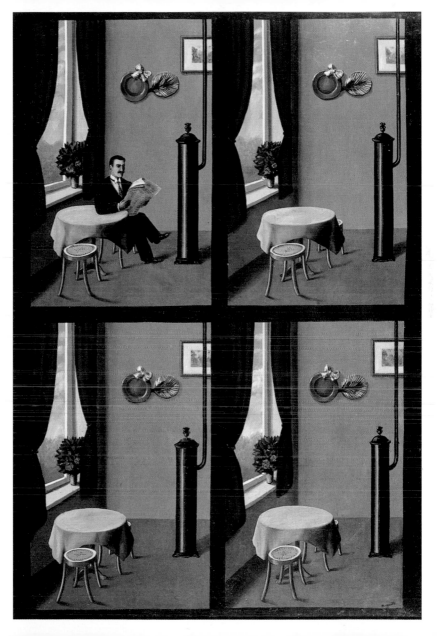

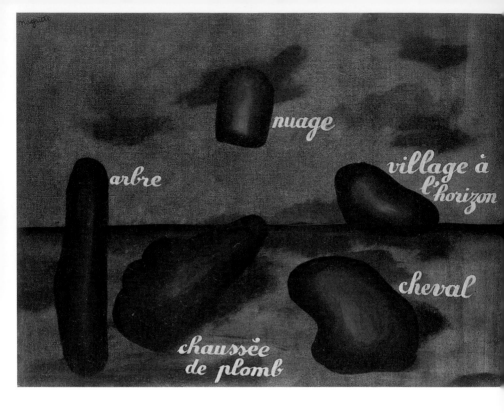

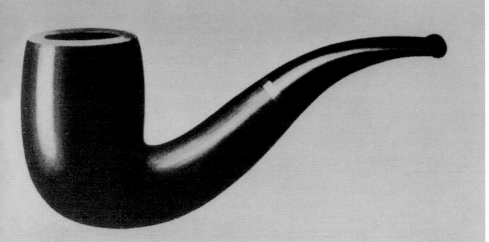

18. René Magritte
L'Espoir rapide
(*The Swift Hope*), 1928

19. René Magritte
La Trahison des images
(*The Treachery of Images*),
1929

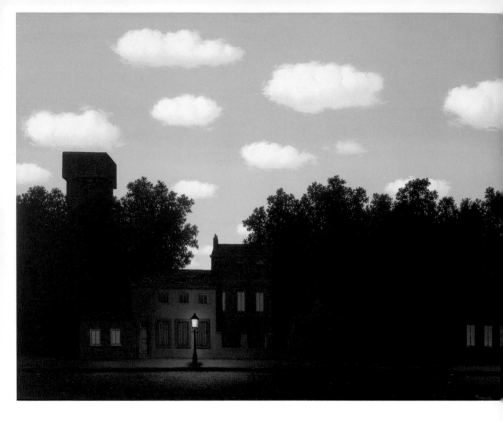

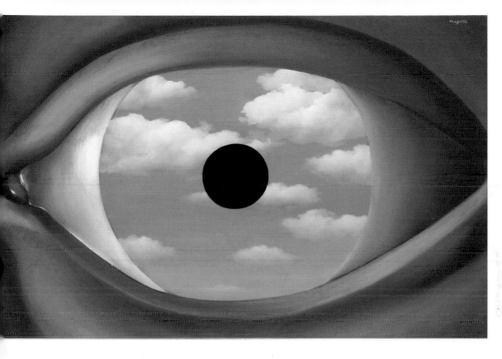

20. René Magritte
The Empire of Light II, 1950

21. René Magritte
The False Mirror, 1929

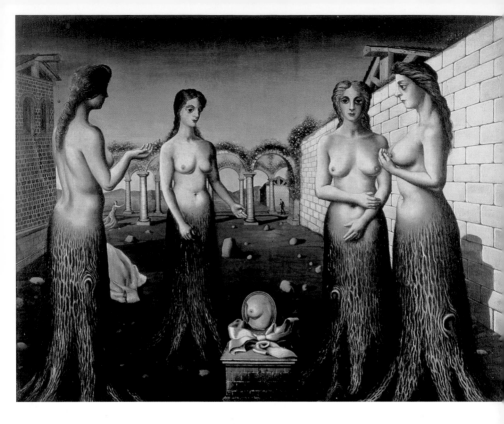

22. Paul Delvaux
The Birth of the Day
(The Aurora), 1937

Following pages

23. Paul Delvaux
Phases of the Moon, 1939

24. Paul Delvaux
The Acropolis, 1966

56

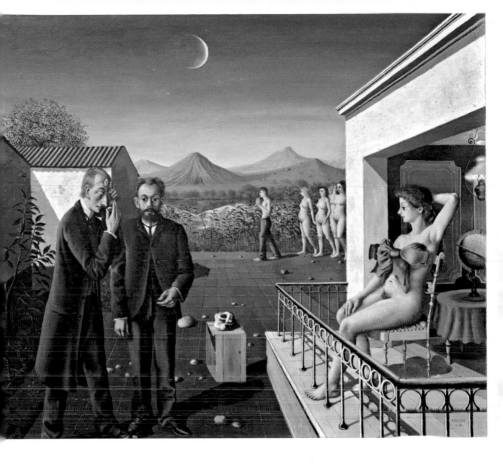

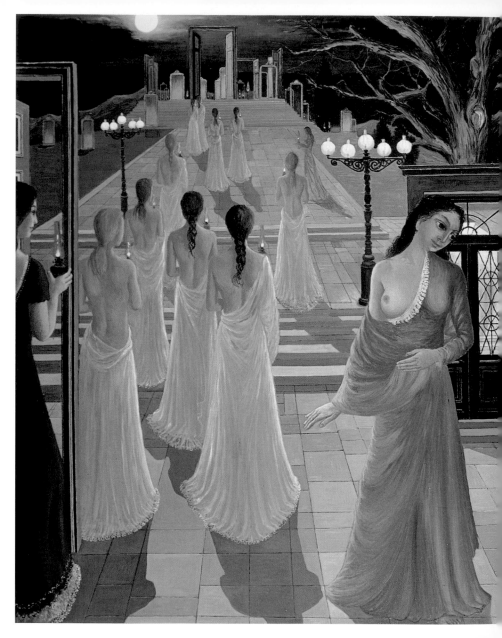

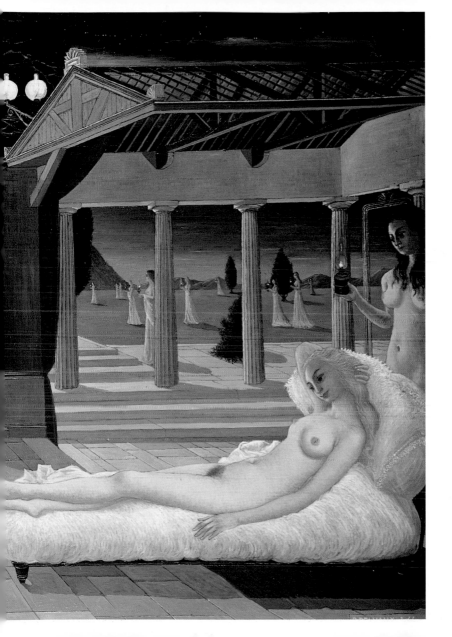

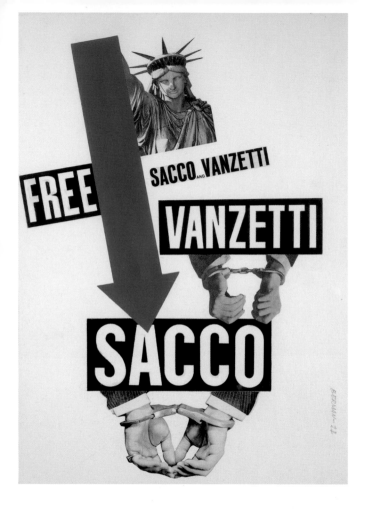

25. Mieczyslaw Berman
Free Sacco and Vanzetti,
1927-65

26. Mieczyslaw Berman
Circus II, 1928

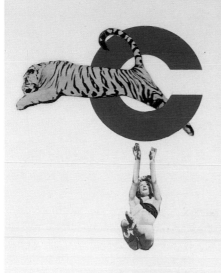
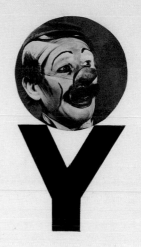

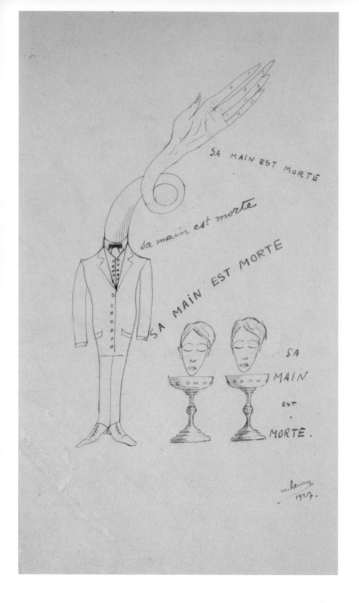

27. Maurice Henry
Sa main est morte
(*His Hand Is Dead*), 1927

28. Maurice Henry
Le guet-apens
(*The Ambush*), 1935

Le guet-apens.

Au printemps une salade du nom de

s'installa dans la salle de bain

comme un

avec lequel longuement
les fenêtres feraient l'amour

mais aussitôt se produisit qui ruina
définitivement

les dernières tentatives de démolition de

Un inconnu avait

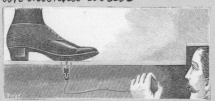

maurice henry
35

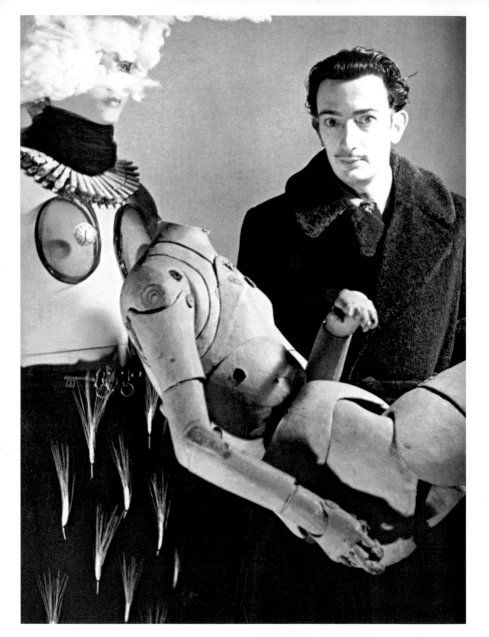

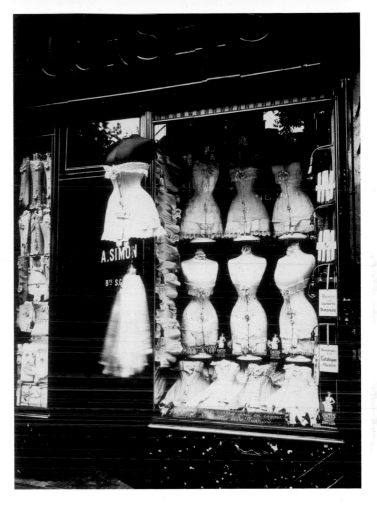

29. Denise Bellon
*Salvador Dalí and His Headless
Mannequin*, 1938

30. Eugène Atget
*Corsets, Boulevard
de Strasbourg*, 1905

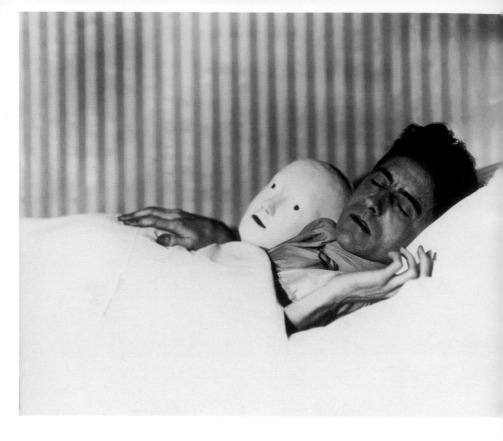

31. Berenice Abbott
*Jean Cocteau in Bed with
the Mask of Antigone*, 1927

32. Philippe Halsman
*Jack-of-all-trades – Jean
Cocteau*, 1949

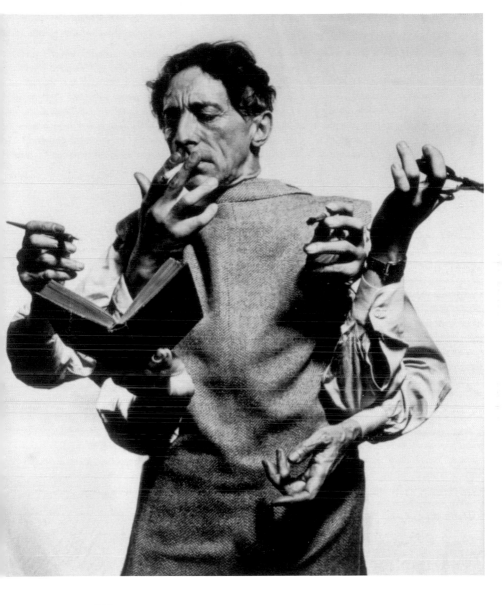

67

33. Luis Buñuel
L'âge d'or (*The Golden Age*),
1930

34. Joan Miró
The Farm, 1921-22

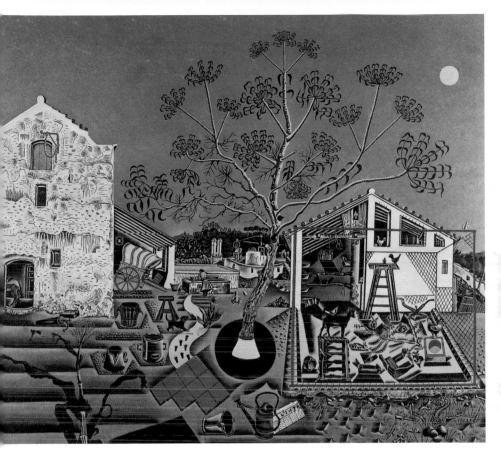

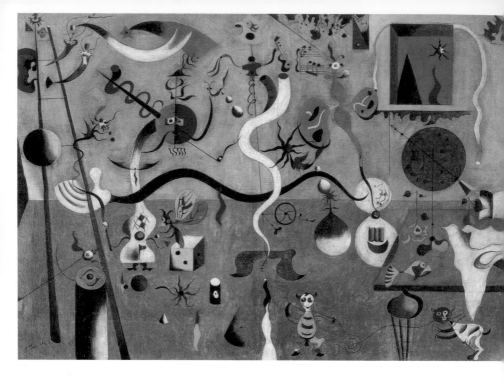

35. Joan Miró
Carnival of Harlequin, 1924-25

36. Joan Miró
Head of Catalan Peasant, 1925

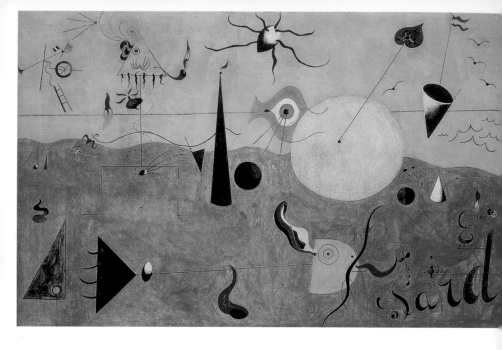

37. Joan Miró
The Hunter
(*Catalan Landscape*), 1923-24

38. Joan Miró
The Gentleman, 1924

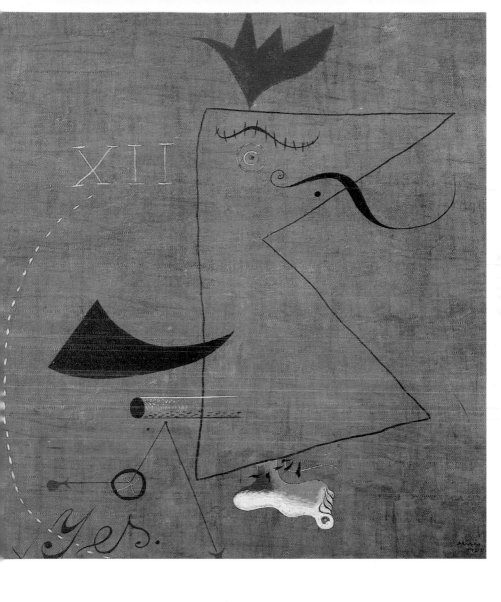

73

39. Joan Miró
Bather, 1925

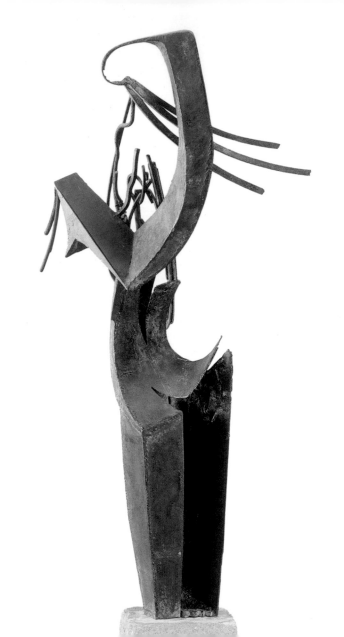

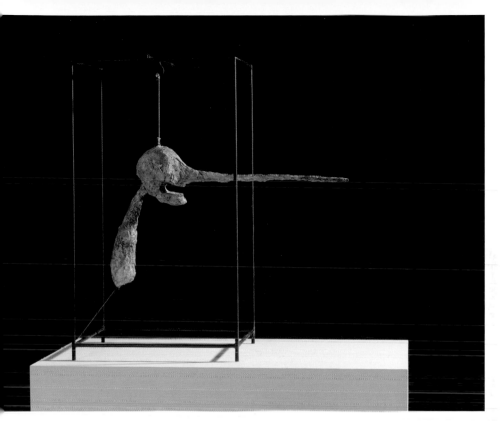

40. Julio González
*Woman Combing
Her Hair*, 1936

41. Alberto Giacometti
The Nose, 1947

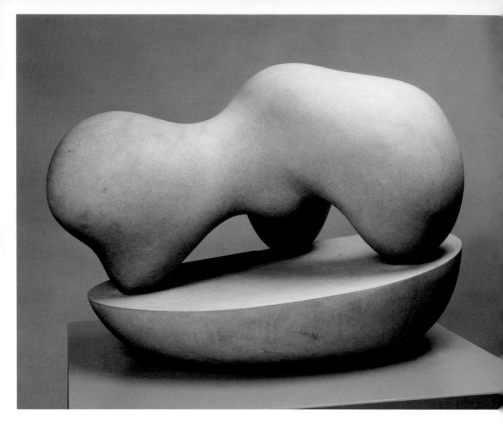

42. Hans Arp
Human Concretion II, 1933

43. Hans Arp
Cloud Shepherd, 1953

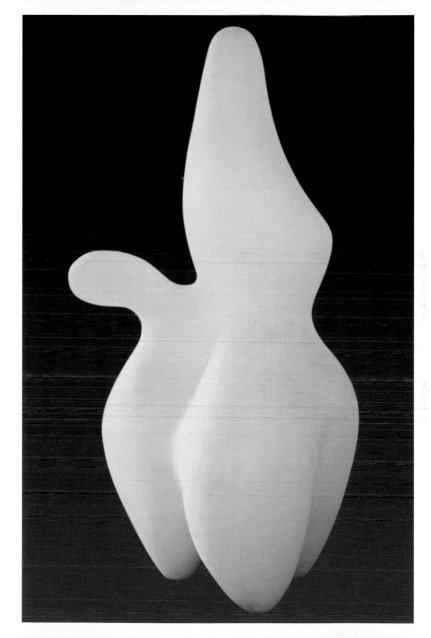

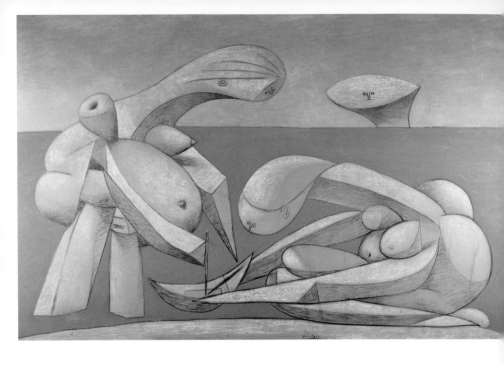

44. Pablo Picasso
*Women Playing
on the Beach*, 1937

45. Pablo Picasso
Seated Bather, 1930

Following pages
46. Pablo Picasso
Woman Throwing a Stone,
1931

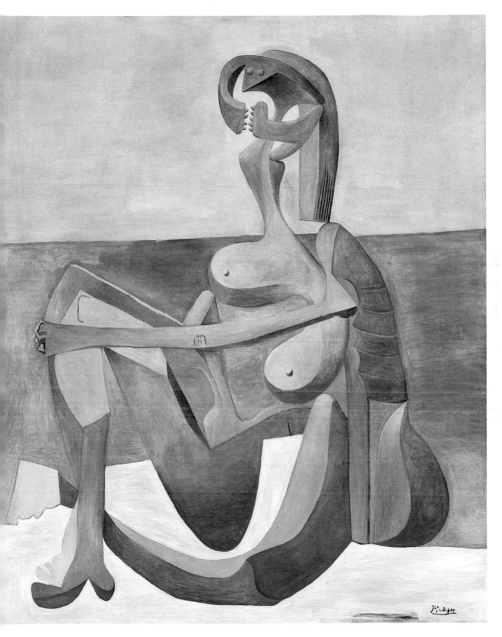

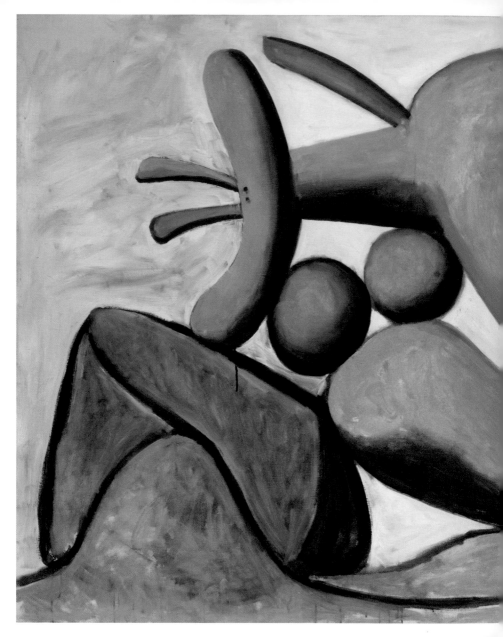

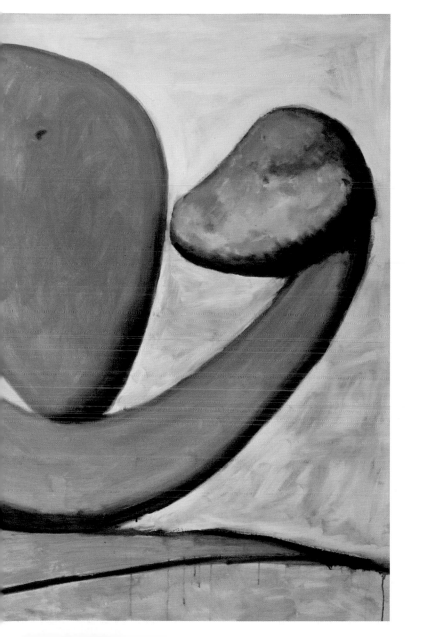

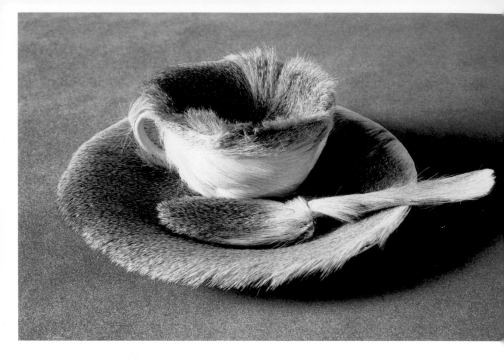

47. Meret Oppenheim
Objet – Déjeuner en fourrure
(*Object – The lunch in Fur*),
1936

48. Joseph Cornell
Taglioni's Jewel Casket, 1940

84

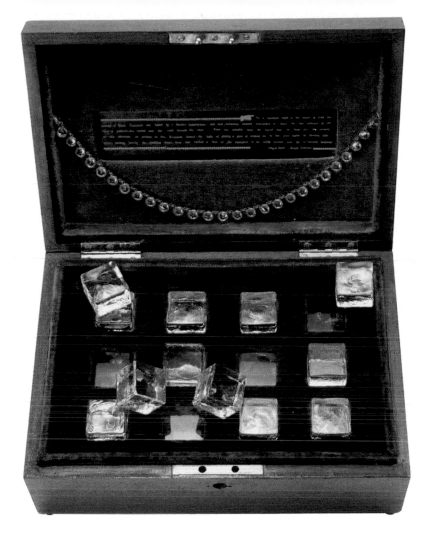

85

Appendix

Catalogue
of the Works

1. Max Ernst
Attirement of the Bride,
1939-40
Oil on canvas, 130 x 96 cm
Peggy Guggenheim
Collection, Venice

2. Man Ray
Le Violon d'Ingres, 1924
Gelatine silver print glued
on paper, pencil and Indian
ink, 31 x 24.7 cm
Musée national d'Art
moderne – Centre Georges
Pompidou, Paris

3. Man Ray
*Primacy of Matter over
Thought*, 1929
Original solarization,
21 x 30 cm
Arturo Schwarz Collection,
Milan
Courtesy Fondazione Mudima

4. Dora Maar
Nusch Éluard, circa 1935
Gelatine silver print,
24.5 x 18 cm
Musée national d'Art
moderne – Centre Georges
Pompidou, Paris

5. Man Ray
Lee Miller, circa 1930
Gelatine silver print,
30.7 x 22.9 cm
Courtesy Fondazione Marconi

6. Man Ray
Venus with Mirror and Lamp,
1931-59
Gelatine silver print
Städtisches Museum
Abteiberg, Mönchengladbach

7. Francis Picabia
*Transparencies – Head
and Horse*, 1930
Brush and ink, gouache
and watercolour on paper,
77 x 59 cm
The Museum of Modern Art,
New York

8. Man Ray
The Tear (Variant), 1932
Gelatine silver print,
27.9 x 15 cm
Publication of Album
1920-34

9. Man Ray
Dora Maar, 1936
Silver proof, 6.5 x 5.3 cm
Telimage, Paris

10. Salvador Dalí
*The Persistence
of Memory*, 1931
Oil on canvas,
24 x 33 cm
The Museum of Modern Art,
New York

11. Salvador Dalí
The Great Masturbator, 1929
Oil on canvas, 110 x 150 cm
Centro de Arte Reina Sofía,
Museo Nacional, Madrid
Dalí Bequest to the Spanish
State

12. Salvador Dalí
The Lugubrious (or *Mournful*)
Game, 1929
Oil and collage on pasteboard,
44.4 x 30.3 cm
Private collection

13. Salvador Dalí
Portrait of Mrs. Isabel Styler-Tas (Melancholia), 1945
Oil on canvas, 65.5 x 86 cm
Preußischer Kulturbesitz,
Staatliche Museen zu Berlin,
Berlin

14. Yves Tanguy
Extinction of Useless Lights,
1927
Oil on canvas, 92.1 x 65.4 cm
The Museum of Modern Art,
New York

15. Yves Tanguy
*Dead Man Watching
His Family*, 1927
Oil on canvas, 100 x 73 cm
Museo Thyssen-Bornemisza,
Madrid

16. René Magritte
The Menaced Assassin, 1926
Oil on canvas,
150.4 x 195.2 cm
The Museum of Modern Art,
New York
Gift of D. and J. de Menil

17. René Magritte
Man with a Newspaper, 1928
Oil on canvas, 116 x 81 cm
Tate Gallery, London,
offered by "The Friends
of the Tate Gallery"

18. René Magritte
L'Espoir rapide
(*The Swift Hope*), 1928
Oil on canvas, 49.5 x 64 cm
Kunsthalle, Hamburg

19. René Magritte
La Trahison des images
(*The Treachery of Images*),
1929
Oil on canvas,
64.45 x 93.98 cm
City County Museum,
Los Angeles

20. René Magritte
The Empire of Light II, 1950
Oil on canvas, 49.5 x 64 cm
The Museum of Modern Art,
New York

21. René Magritte
The False Mirror, 1929
Oil on canvas, 54 x 81 cm
The Museum of Modern Art,
New York

22. Paul Delvaux
*The Birth of the Day
(The Aurora)*, 1937
Oil on canvas,
120 x 150.5 cm
Peggy Guggenheim
Collection, Venice

23. Paul Delvaux
Phases of the Moon, 1939
Oil on canvas,
139.7 x 160 cm
The Museum of Modern Art,
New York

24. Paul Delvaux
The Acropolis, 1966
Oil on canvas, 150 x 230 cm
Musée national d'Art
moderne – Centre Georges
Pompidou, Paris
Purchase, 1969

25. Mieczyslaw Berman
Free Sacco and Vanzetti,
1927-65
Collage, 70 x 50 cm
Private collection

26. Mieczyslaw Berman
Circus II, 1928
Collage, 70 x 50 cm
Private collection

27. Maurice Henry
Sa main est morte
(*His Hand Is Dead*), 1927
Indian ink on paper,
43.2 x 30 cm
Private collection

28. Maurice Henry
Le guet-apens
(*The Ambush*), 1935
Indian ink and collage on
cardboard, 26.5 x 20 cm
Private collection

29. Denise Bellon
*Salvador Dalí and His
Headless Mannequin*, 1938
Les Films de l'Equinoxe

30. Eugène Atget
*Corsets, Boulevard
de Strasbourg*, 1905
Gelatine silver print,
23.3 x 17.2 cm
Rheinisches Bildarchiv
Museum Ludwig, Cologne

31. Berenice Abbott
*Jean Cocteau in Bed with
the Mask of Antigone*, 1927
Silver proof from the original
negative

32. Philippe Halsman
*Jack-of-all-trades – Jean
Cocteau*, 1949
Gelatine silver print
Philippe Halsman/Magnum
Photos

33. Luis Buñuel
L'âge d'or (The Golden Age),
1930
Talking film in black and white,
35 mm
Duration: 63 minutes
Musée national d'Art
moderne – Centre Georges
Pompidou, Paris
Donation, 1989

34. Joan Miró
The Farm, 1921-22
Oil on canvas,
123.8 x 141.3 cm
National Gallery of Art,
Washington, Gift of Mary
Hemingway

35. Joan Miró
Carnival of Harlequin,
1924-25
Oil on canvas, 66 x 93 cm
Albright-Knox Art Gallery,
Buffalo

36. Joan Miró
Head of Catalan Peasant,
1925
Oil on canvas, 91 x 73 cm
Roland Penrose Collection,
London

37. Joan Miró
*The Hunter (Catalan
Landscape)*, 1923-24
Oil on canvas, 65 x 100 cm
The Museum of Modern Art,
New York

38. Joan Miró
The Gentleman, 1924
Oil on canvas, 52 x 46 cm
Kunstmuseum, Basel

39. Joan Miró
Bather, 1925
Oil on canvas, 73 x 92 cm
Collection Michel Leiris, Paris

40. Julio González
*Woman Combing
Her Hair*, 1936
Wrought iron,
132.1 x 59.7 x 62.4 cm
The Museum of Modern Art,
New York
Mrs Simon Guggenheim Fund

41. Alberto Giacometti
The Nose, 1947
Painted plaster, string and
metal, 82.6 x 77.5 x 36.7 cm
Musée national d'Art
moderne – Centre Georges
Pompidou, Paris
Gift of the Aimé Maeght
Bequest, 1992

42. Hans Arp
Human Concretion II, 1933
Marble, 47 x 74 x 45.5 cm
Kunsthaus, Zurich

43. Hans Arp
Cloud Shepherd, 1953
Plaster, 320 x 123 x 220 cm
Musée national d'Art
moderne – Centre Georges
Pompidou, Paris

44. Pablo Picasso
*Women Playing
on the Beach*, 1937
Oil on canvas, 129 x 194 cm
Peggy Guggenheim
Collection, Venice

45. Pablo Picasso
Seated Bather, 1930
Oil on canvas,
163.2 x 129.5 cm
The Museum of Modern Art,
New York

46. Pablo Picasso
Woman Throwing a Stone,
1931
Oil on canvas,
130.5 x 195.5 cm
Musée National Picasso, Paris

47. Meret Oppenheim
*Objet – Déjeuner en fourrure
(Object – The lunch in Fur)*,
1936
Cup, saucer and spoon
covered with fur,
10.9 cm (diameter cup),
23.7 cm (diameter saucer),
20.2 cm (spoon)
7.3 cm (overall height)
The Museum of Modern Art,
New York

48. Joseph Cornell
Taglioni's Jewel Casket, 1940
Wooden box containing glass
ice cubes, jewellery, etc.,
12 x 30.2 x 21 cm
The Museum of Modern Art,
New York
Gift of James Thrall Soby

Artistical events	Historical events
1917 Apollinaire uses the term "sur-réalisme" in the programme of *Parade*, at the Théâtre du Châtelet.	
1918	The First World War ends.
1920 Publication of *Les champs magnétiques*, by André Breton and Philippe Soupault, dedicated to experiments with automatic writing. Beginning of the Dadaist soirées.	
1921 The Salon Dada is held, with Arp and Ernst taking part.	Arrest of Sacco and Vanzetti for murder.
1924 Breton writes the "Manifesto of Surrealism".	
1925 First surrealist exhibition at the Galerie Pierre.	Chaplin's *Gold Rush*.
1929 Dalí joins the group of Surrealists in Paris. The last issue of *La révolution surréaliste* comes out, with Breton's "Second Manifesto of Surrealism". Alberto Moravia writes the novel *Gli indifferenti* (*Time of Indifference*).	Crash on the Stock Exchange in New York, triggering the worldwide depression. St. Valentine Day's Massacre. Opening of the Museum of Modern Art in New York.
1930 Dalí collaborates with Buñuel on the film *L'Âge d'or*, shown for the first time at Studio "28" in Paris. There is uproar during the screening and paintings by Ernst, Miró, Dalí, Tanguy and Man Ray are destroyed.	France begins construction of the Maginot Line. The following year the Republicans win the elections in Spain. Shortly afterwards the Nazi Party wins in Germany. Discovery of the planet Pluto.
1934 Dalí leaves the group of Surrealists.	Luigi Pirandello receives the Nobel Prize for Literature. The Bauhaus has been closed for a year.
1936 The exhibition *Fantastic Art, Dada, Surrealism* is held at the Museum of Modern Art in New York. The *International Surrealist Exhibition* is staged at the Burlington Gallery in London.	In Spain the Popular Front wins the elections and this sparks off civil war. García Lorca, with Alberti and Bergamín, founds the Association of Antifascist Intellectuals.

	Artistical events	Historical events
1937	Picasso paints *Guernica*.	Works of modern art are condemned in Berlin and will subsequently be removed from all German museums.
1938	Surrealist exhibition at the Galerie des Beaux-Arts in Paris. Ernst and Éluard leave the Surrealists. Breton meets Trotsky and they write the manifesto *Pour un art révolutionnaire indépendant* together.	Annexation of Austria to Germany. Racial laws in Italy.
1939	Definitive break between Dalí and Breton.	Poland is invaded by German troops: the Second World War breaks out. Victory of Franco in Spain.
1940	Breton, Ernst and Masson arrive in New York. Dalí leaves France and goes to California; two years later he publishes *The Secret Life of Salvador Dalí*.	The German army enters Paris on 14 June. Mussolini announces Italy's entry into the war. Trotsky is assassinated in Mexico. Léger, Mondrian and the Surrealists move to New York.
1943	Action painting comes into being at Peggy Guggenheim's gallery.	On 8 September Italy announces an armistice with the Allied forces.
1945		The Second World War ends with the unconditional surrender of the Third Reich.
1946	Dalí designs the scenes of Hitchcock's *Spellbound*.	The Nuremberg trials are held.
1947	The last Surrealist joint exhibition is staged at the Galerie Maeght in Paris.	
1948		Gandhi is assassinated. Israel proclaims independence. The Republican Constitution comes into force in Italy.

Biographies
of the main Artists

André Breton
(Tinchebray, 1896 – Paris, 1966)
Breton was born in 1896. From 1913 on
he published his writings in *La Phalange*
and in 1914 met Paul Valéry. In 1915 he
wrote *Décembre*, which he sent to Apollinaire.
Founder of the avant-garde magazines
Littérature, with Aragon and Soupault, *La
Révolution Surréaliste* and *Le Surréalisme
au service de la Révolution*, he published
the *Manifesto of Surrealism* in 1924. In 1920,
along with Soupault, he explored his interest
in psychoanalysis in the essay *Magnetic
Fields* (he would meet Freud in Vienna in
1921). In 1926 he wrote *Le Surréalisme
et la Peinture* ("Surrealism and Painting");
in the same years he organized a number
of fundamental exhibitions, from *Surrealist
Painting* to several international shows.
He died in Paris on 28 September 1966.

Salvador Dalí
(Figueras, 1904 – Figueras, 1989)
Gifted with a precocious talent, he studied
Fine Arts in Madrid in the twenties, making
friends with people like García Lorca and
Buñuel, with whom he collaborated on the
making of *Un Chien andalou* (1928) and
L'Âge d'or (1930). After initially painting
pictures influenced by Futurism, Metaphysical
art and Cubism, he made a visit to Paris in
1926, getting to know Picasso, Breton, Miró
and Éluard (falling in love with the latter's
wife, Gala) and took up Surrealism: out of this
came works like *The Persistence of Memory*
(1931) and *The Great Paranoiac* (1936). In

1982 the artist moved to Púbol, where he
remained almost in isolation before moving
back to Figueras, dying there in 1989. The
majority of his works were bequeathed to the
Spanish State.

Paul Delvaux
(Antheit, 1897 – Furnes/Veurne, 1994)
He was born near Liège on 23 September
1897. Despite the disapproval of his parents,
he studied painting and architecture at the
Académie Royale des Beaux-Arts in Brussels
from 1920 to 1924. In 1925 he held his first
solo exhibition, showing landscapes couched
in a primitivist neo-naturalism. Over the
following years his style changed radically,
given his fascination with the art of de Chirico
and Magritte, and in particular with the
detached presentation of ordinary objects in
unexpected combinations.
He was also impressed by the creations of
Ensor, Dalí, Ernst, Miró and Balthus and this
led him to join the Surrealist movement. In the
forties and fifties his style underwent further
modification. He painted several murals, at
the Palais du Congrès in Brussels, the
Ostend Casino and the Institute of Zoology
in Liège. In 1965 he was appointed director
of the Académie Royale des Beaux-Arts in
Belgium. He died at Veurne on 20 July 1994.

Max Ernst
(Brühl, 1891 – Paris, 1976)
Max Ernst was born in 1891. Enrolling in the
faculty of philosophy at Bonn University, he
was then drawn to the world of art, in part
through his friendship with people like
Delaunay and Apollinaire. His journey took
him through Expressionism and Dadaism, and
only later, partly owing to the influence of de
Chirico's work, did he become one of the
founders of Surrealism: in 1924 he wrote the
Traité de la peinture surréaliste. In 1929 he

showed in Paris for the first time; the following year he collaborated with Dalí and Buñuel on the film *L'Âge d'or*. He created numerous collage-novels, using images from catalogues and encyclopaedias. In 1941, fleeing the war, he went to the United States, staying there until 1954; in 1942 he married Peggy Guggenheim, whom he divorced a few years later to marry Dorothea Tanning. He died in Paris on 1 April 1976.

René Magritte
(Lessines, 1898 – Brussels, 1967)
Magritte was born in 1898, the son of a tailor and merchant. His family travelled a great deal, moving house frequently, and in 1910 he arrived in Châtelet, where his mother probably took her own life. When they moved again to Charleroi he began to show an interest in painting, and in 1916 enrolled at the Académie Royale des Beaux-Arts in Brussels. In 1922 he got married and found a job designing wallpaper. The following year he sold his first picture, a portrait of the singer Evelyn Brélin. In 1925 he joined the Surrealist movement, largely due to the influence of Giorgio de Chirico. In 1927 he held his first one-man show at the Galerie Le Centaure in Brussels. The following year he went to live at Perreux-sur-Marne, but in 1940, frightened by Nazism, moved to Carcassonne, in the South of France. A series of different phases followed his Surrealist period, including the ones known as "*solaire*" and "*vache*". In 1967, after making a long journey to Cannes, Montecatini and Milan, he died in Brussels.

Man Ray
(New York, 1890 – Paris, 1976)
Born in 1890 as Emmanuel Radnitzky, he decided to devote himself to art following his first contacts with Alfred Stieglitz. In 1915 some of his photographs were shown at the exhibition *The Modern Movement in American Art*. Marcel Duchamp, who had just put his famous urinal *Fontaine* on show, became his friend. In 1921 the pair of them moved to Paris, where Duchamp introduced the American into the circle of Surrealists. At the same time as he produced his first rayographs, his fashion photographs were published in the magazines *Harper's Bazaar* and *Vogue*. In 1925 he took part in the first joint Surrealist exhibition at the Galerie Pierre. An important phase in Man Ray's life was marked by his encounter, in 1929, with the American photographer Lee Miller, with whom he invented the technique of solarization. In 1940 he went to live in Los Angeles. Ten years later, in 1951, he returned to Paris for good and devoted himself chiefly to colour photography. He died at the age of eighty-six in his house in Montparnasse.

Joan Miró
(Barcelona, 1893 – Palma de Majorca, 1983)
He was born in Barcelona in 1893. Around 1912 the art dealer Josep Dalmau introduced him to Maurice Raynal and Francis Picabia. He held his first solo exhibition at Dalmau's gallery in Barcelona. In 1920 he was in Paris, where he met Picasso, Masson, Michel Leiris, Antonin Artaud, Jean Dubuffet, Paul Éluard and Raymond Queneau. In 1925 he got to know Breton and took part in some Surrealist events. In 1932 he moved back to Barcelona, but in 1936, on the outbreak of the Spanish Civil War, he took his family to Paris. Following the German invasion of France (1940) Miró returned Spain. He settled at Palma de Majorca. A major retrospective of his work was held at the Museum of Modern Art in New York in 1941. From 1944 onward he devoted himself to ceramics, creating a number of works on a monumental scale: in 1958 his wall panels for the UNESCO

Building in Paris were unveiled. In 1972 the Joan Miró Foundation was set up in Barcelona. He died in Palma de Majorca in 1983.

Francis Picabia
(Paris, 1879-1953)
He was born to a French mother and a Spanish father, who was attaché at the Cuban embassy in Paris. He studied at the Académie des Beaux-Arts and, at the beginning of his career, was strongly influenced by the Barbizon School, Alfred Sisley and Camille Pissarro, and then by Impressionism, Cubism and Abstractionism. Around 1911 he made friends with Marcel Duchamp and met Apollinaire, Albert Gleizes, Roger de La Fresnaye, Fernand Léger and Jean Metzinger. From 1913 to 1915 he was often in New York and played an active part in the city's avant-garde movements. Later, in 1916, he brought out the first issue of the Dadaist periodical *391* in Barcelona, in which he published his first mechanical drawings. In 1925 he developed an interest in Surrealism: moving to the Côte d'Azur, he developed a style of painting defined as that of "monsters" and "transparencies". After an interlude of abstraction in the post-war period, he returned to Surrealism and published the magazine *491* with Breton. He died in Paris, in the same house in which he was born, on 30 November 1953.

Pablo Picasso
(Malaga, 1881 – Mougins, 1973)
In 1895 he moved to Barcelona, where he enrolled in the art academy (La Llotja). It was there that he held his first one-man show at the café Els Quatre Gats. In 1900 he was in Paris where, after a first so-called "Blue Period" (1901-04), he settled permanently in 1904. He met Guillaume Apollinaire and

many other artists, as well as Fernande Olivier, who became his mistress. His new acquaintances and a great interest in the circus led to the "Pink Period" (1905-06). The year of 1907 was a turning-point: he went to see the major retrospective devoted to Cézanne and was profoundly affected by it. He also came into contact with African sculpture. Out of these stimuli came *Les Demoiselles d'Avignon*, the painting that is considered to mark the official beginning of Cubism. The same year he got to know Braque. He also met Daniel-Henry Kahnweiler, who was to become his principal dealer. He started to carry out the research that in 1910 was to culminate in what is called "Analytical Cubism" (1910-12). Over the following years he and Braque developed a new conception of Cubism defined as "Synthetic" (1912-14). Inserts of materials different from oil paint made their appearance on the canvas, culminating in the *papiers collés*. In 1917 he met Cocteau. Together they made a journey to Italy, to discuss the design of scenes and costumes for the ballet *Parade* with the Russian choreographer Diaghilev. In 1918 he married Olga Kokhlova. The visit to Italy resulted in the "Classical Period". In 1923 he formed a close connection with Surrealism and took part in the first Surrealist exhibition at the Galerie Pierre. From the mid-twenties onwards he showed a growing interest in sculpture and graphic art. In 1935 he illustrated the cycle of the *Minotauromachia*. In 1936 the Spanish government commissioned a work from him for the World's Fair in Paris. The artist painted the picture *Guernica* (1937), dedicated to the Basque town destroyed by German bombing. In 1947, at Vallauris, he began to produce his first ceramics. A major retrospective was held in Paris in 1967. He died at Mougins in 1973.

Selected Bibliography

A. Breton, *Manifeste du Surréalisme*, Paris 1924

A. Breton, *Nadja*, Paris 1928

S. Dalí, *La femme visible*, Paris 1930

Minotaure, nn. 1-13, Paris 1933-39

S. Dalí, *La Conquête de l'Irrationnel*, Paris 1935

A. Breton, *L'amour fou*, 1937

S. Dalí, *The Secret Life of Salvador Dalí*, New York 1942

G. Picon, *Journal du Surréalisme. 1919-1939*, Geneva 1956

S. Dalí, *Journal d'un génie*, Paris 1964

A. Breton, *Le Surréalisme et la Peinture*, Paris 1965

P. Waldberg, *Chemins du Surréalisme*, Köln 1967

S. Dalí, *Dix recettes d'immortalité*, Paris 1973

M. Foucault, *Ceci n'est pas une pipe*, Paris 1973

S. Dalí, *Cinquante secrets magiques*, Lausanne 1974

D. Sylvester, *Dada and Surrealism reviewed: a brief guide to the exhibition*, exhibition catalogue, London, 1978

J. Clébert, *Dictionnaire du Surréalisme*, Paris 1996

M. Gale, *Dada & surrealism*, London 1997

J. Malt, *Object and fetish in constructions of a surrealist revolutionary aesthetic*, Cambridge 1999

A. Joubert, *Le mouvement des surréalistes, ou le fin mot de l'histoire: mort d'un groupe, naissance d'un mythe*, Paris 2001

W. Bohn, *The rise of Surrealism: Cubism, Dada and the pursuit of the marvelous*, Albany 2002

C. Rabinovitch, *Surrealism and the sacred: power, eros and the occult in modern art*, Boulder-Oxford 2002

D. Hopkins, *Dada and Surrealism*, Oxford 2004

K. Grant, *Surrealism and the visual arts: theory and reception*, Cambridge-New York 2005

M. Richardson, *Surrealism*, London 2005

D. Ades, S. Baker (edited by), *Undercover Surrealism: Georges Bataille and Documents*, exhibition catalogue, London, 2006

N. Matheson (edited by), *The sources of Surrealism*, Aldershot 2006

T. McNeese, *Salvador Dalí*, New York 2006

M. Richardson, *Surrealism and cinema*, Oxford 2006

W.L. Adamson, *Embattled avant-gardes: modernism's resistance to commodity culture in Europe*, Berkeley-London 2007

H. Finkelstein, *The screen in surrealist art and thought*, Aldershot 2007

A. Linford, *Surrealist masculinities: gender anxiety and the aesthetics of post World War I reconstrucion in France*, Berkeley-London, 2007

G. Wood, *Surreal things: Surrealism and design*, London 2007